STREET ART IN THE TIME OF CORONA

XAVIER TAPIES

GINGKO PRESS

INTRODUCTION

Of all the art forms, street art was uniquely
equipped to define the extraordinary time when the
Covid-19 Corona Virus swept through the world
in 2020. A grim reaper straight out of the middle
ages, seemed suddenly to be stalking our carefully
ordered consumerist, globalised world. National and
international moods were changing on a daily basis.
Politicians, many useless or inept, struggled to make
the judgement call on how to deal with the virus.
Some decided to 'follow the science', despite the fact
that no two scientists agreed on how to cope with it.
Economies were collapsed overnight, surviving on
funny money. This was not a time for 'high art', which,
arguably, with the notable exception of Picasso's
Guernica, has struggled to really capture the visceral
emotions felt by most modern people when faced with
an existential crisis. So onto the streets, in true street
art tradition breaking the rules, many street artists
stepped in.

The artists represented here capture myriad emotions:
from the restrictions on physical and passionate
contact (C215, Gnasher and Pøbel), to the heroism
of front-line medical staff (Ardif, BustArt, Combo,
Fake, John D'oh); from the nutty obsessions with loo

paper (Hijack) to oppressive governments restricting freedoms (Mgr Mors, TV Boy); from the weirdness of Personal Protective Equipment (Jilly Ballistic, Xamoosh, Damien Mitchell, Lionel Stanhope) to the feeling of all-pervading sickness (Malakkai, Munizer, Laureth Sulfate).

Of course there is sardonic humour in spades. Corona beer (which we love and are drinking plenty of: we hope their sales are going up) provides opportunities for puns and jokes; children playfully setting off Corona bombs; silly government messages telling us not to do stuff. But Trump, sadly, doesn't feature much: as many artists have found, the man really is beyond parody. And there is also sensitivity, notably in the work of seiLeise, capturing the weirdness of the pandemic for children and the vulnerability of the elderly.

The intention of this book was to capture this amazing art and to serve also as a memento. But we'd also like it to be a call to arms, for more of the world's brilliant street artists to unlock themselves and go express all the moods of these very strange times.

Xavier Tapies.

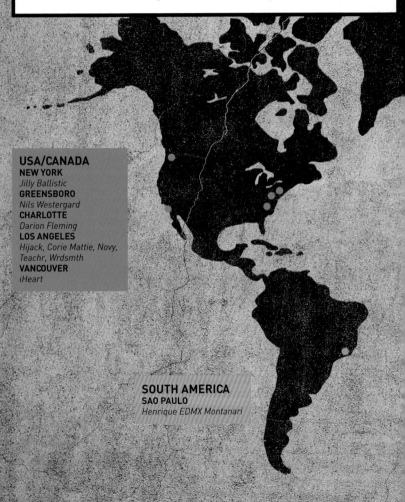

CORONA STREET ART AROUND THE WORLD

As the Corona virus spread to all corners of the globe, so street artists from every continent captured the mood of this extraordinary time. China, where the virus originated, was a striking exception.

USA/CANADA
NEW YORK
Jilly Ballistic
GREENSBORO
Nils Westergard
CHARLOTTE
Darion Fleming
LOS ANGELES
Hijack, Corie Mattie, Novy, Teachr, Wrdsmth
VANCOUVER
iHeart

SOUTH AMERICA
SAO PAULO
Henrique EDMX Montanari

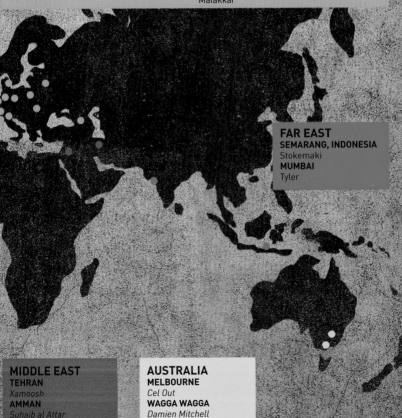

EUROPE

PARIS
Anastasiaa and 33,
Ardif, Combo, Eddie
Colla
IVRY-SUR-SEINE
C215
LYON
Laureth Sulfate
COLOGNE
ARMX and Sweetsini,
seiLeise

VIENNA
Ben Apache, Deadbeat
Hero
BINNINGEN
BustArt
VAUD
Sid
MADRID
Munizer
BARCELONA
TV Boy
LONDON
Lionel Stanhope

BRISTOL
John D'oh
ROYSTON
Gnasher
DUBLIN
ESTR
AMSTERDAM
Fake
LUXEMBOURG
Mope
MILAN
Ragazzini
COPENHAGEN
Malakkai

BRYNE
Pobel
BERGEN
Pyritt
NOWY SACZ
Mgr Mors
TBILISI
Gleb Kashtanov
BREST, BELARUS
Severniy Veter

FAR EAST
SEMARANG, INDONESIA
Stokemaki
MUMBAI
Tyler

MIDDLE EAST
TEHRAN
Xamoosh
AMMAN
Suhaib al Attar

AUSTRALIA
MELBOURNE
Cel Out
WAGGA WAGGA
Damien Mitchell

5

FUTURE DREAMING
Anastasiaa and 33°

Russian artist Anastasiaa, with a wistful image on a Paris wall, praying for the end of the Corona pandemic.

LOCATION:
Paris, France

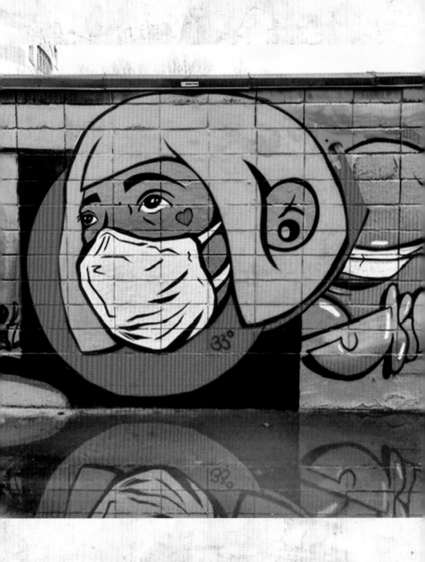

DISTANCE, HOPE AND BUNNIES
BEN APACHE

Two mysterious figures going in opposite directions. One is protected by a plague mask. The other looks to nature to help us conquer the virus.

LOCATION:
Vienna, Austria

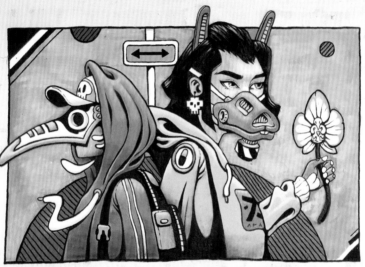

MERCI
Ardif

Ardif sees similarities between the grit and determination of today's nurses and women at the time of the Revolution. He thanks both.

LOCATION:
Paris, France

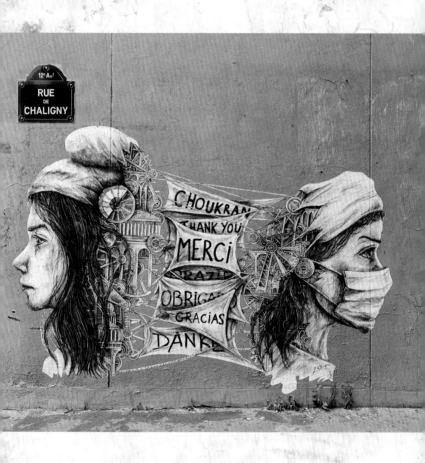

11

COVID-19
ARMX and Sweetsnini

Two mischievous children in masks, straight out of their nursery, think it would be a fun game to unleash a Covid-19 bomb on the world.

LOCATION:
Cologne, Germany

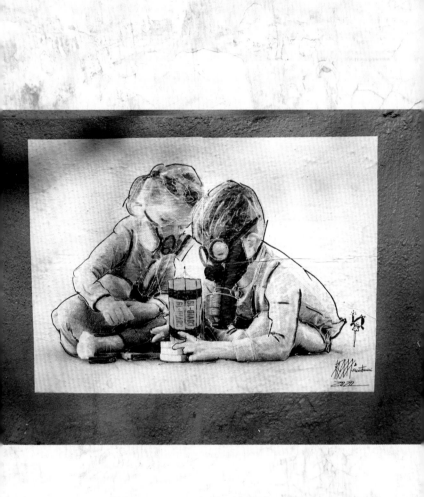

VIRUS
ARMX and Sweetsnini

A call to arms from spray painters to defeat the virus. The unobscured 'US' speaks of solidarity: together we will prevail.

LOCATION:
Cologne, Germany

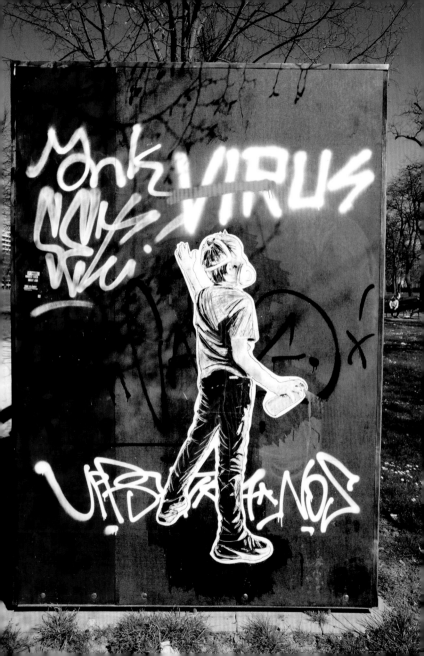

HEROES OF OUR TIME
BustArt

A professional and reassuring nurse, working to save lives on the frontline. Without question also a superwoman.

LOCATION:
Binningen, Switzerland

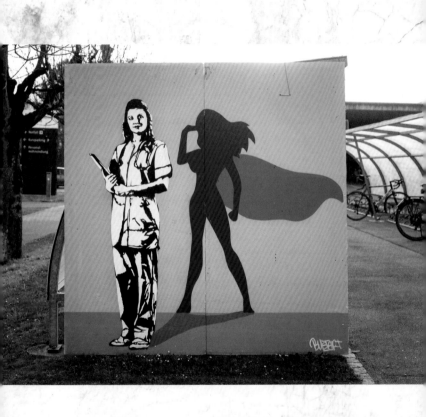

ADJUSTMENTS
C215

An image of freedoms lost. Love must be expressed through Hazmat suits and plastic shields. The emotion is still strong, however.

LOCATION:
Ivry-sur-Seine

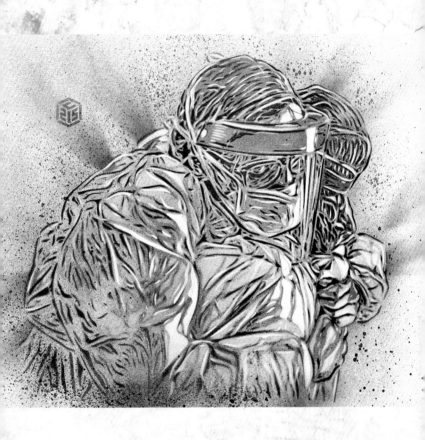

L'AMOUR AU TEMPS DU CORONAVIRUS
C215

Passion despite the masks. A stunningly bright image of young love from C215.

LOCATION:
Ivry-sur-Seine

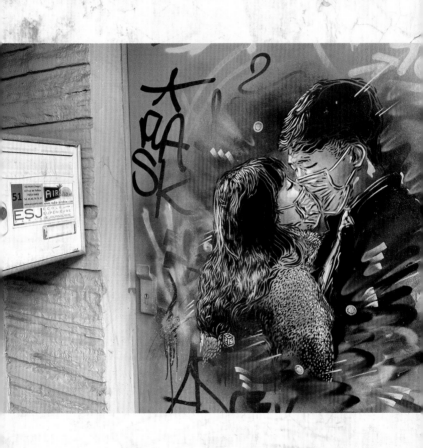

AY CORONA!
Cel Out

Bart Simpson's usual cry of 'Ay Caramba!' superseded as a cloud of viruses envelop his head.

LOCATION:
Melbourne, Australia

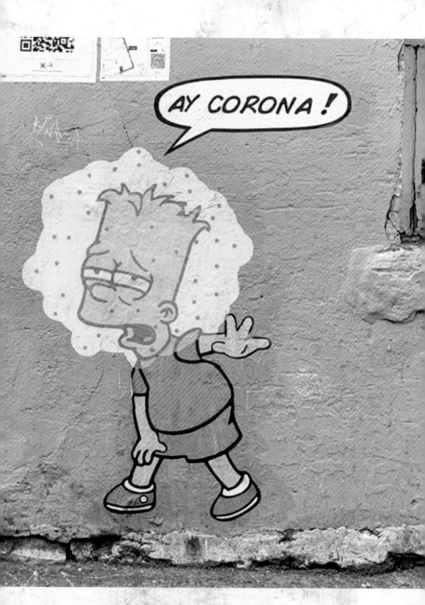

GIRL WITH MASK
Eddie Colla

A wonderfully defiant, pre-Covid-19 image, which acquired extra resonance in 2020. The mask is a surgical blue, suggesting a nurse.

LOCATION:
Paris, France

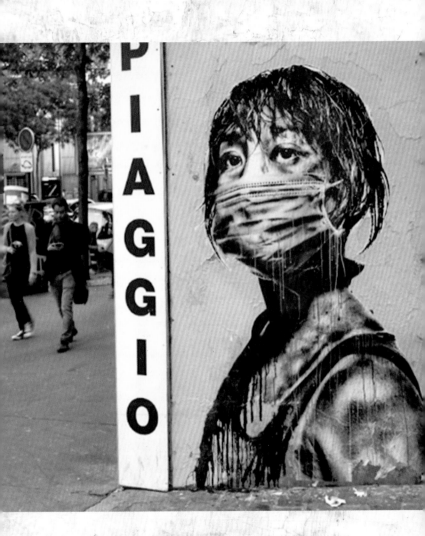

25

WONDER NURSE
Combo

A nurse in classic Wonder Woman pose, reflecting her superhuman powers. The strappy high heels aren't quite regulation hospital wear.

LOCATION:
Paris, France

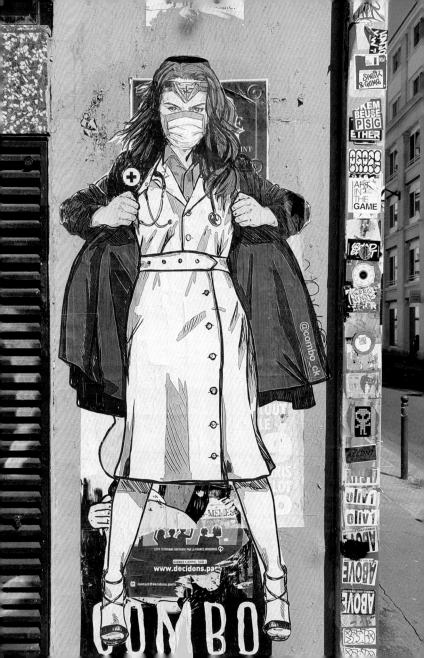

STAY POSITIVE
Deadbeat Hero

One of Deadbeat's strange robots, ironically suggesting we stay postive as Corona leads to major body malfunctions.

LOCATION:

Vienna, Austria

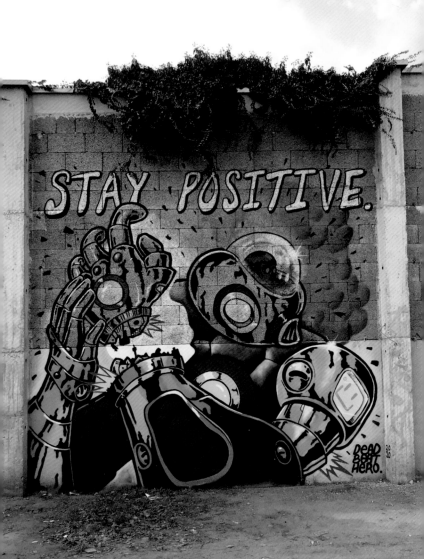

WASH YOUR HANDS
Deadbeat Hero

Another of Deadbeat's crazy robots, here frantically (and mockingly?) telling us firmly to wash our hands!

LOCATION:
Vienna, Austria

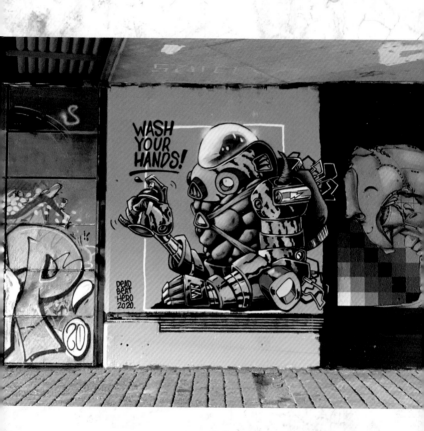

NHS HEROES
John D'oh

Corona saw an outpouring of love and respect for the UK's National Health Service and its frontline workers, reflected in this image.

LOCATION:
Bristol, UK

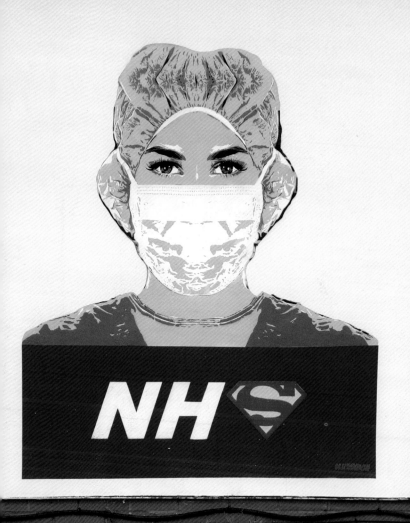

TRUMP DISINFECTANT
John D'oh

Trump's moronic (he later said it was 'ironic') suggestion that we drink disinfectant to fight the virus. D'oh uses a somewhat younger image of the president, but still captures his emotionless look.

LOCATION:
Bristol, UK

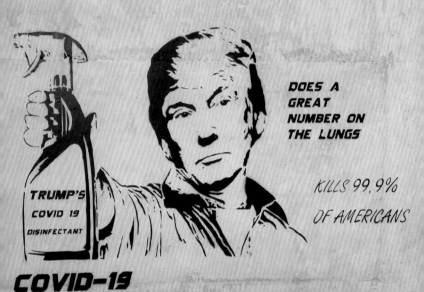

DON'T SHIT YOURSELF
John D'oh

Hilarious, punning comment on the rush to buy toilet paper as the virus was announced, as if our terror would cause us to need it more often.

LOCATION:
Bristol, UK

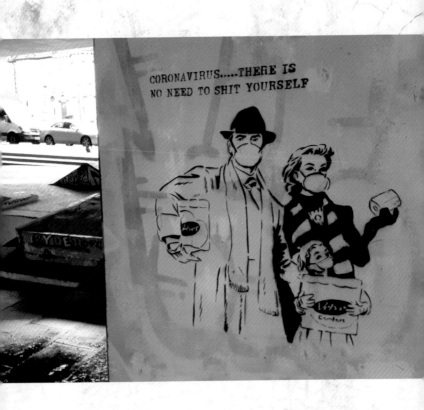

37

DON'T SHOW UP
ESTR

ESTR cleverly usurps Dua Lipa's lyrics from *Don't Start Now* to get the Lockdown message across, brightening up grey Dublin skies in the process.

LOCATION:
Tallaght, Dublin, Ireland

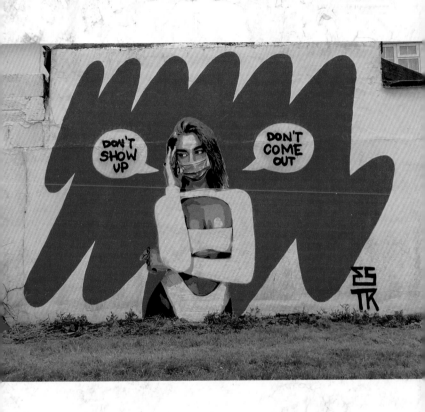

DON'T STAND SO CLOSE
ESTR

ESTR brilliantly captures the beat of the Police's Don't Stand So Close To Me. If coronavirus needed a theme song, this would be it.

LOCATION:
Tallaght, Dublin, Ireland

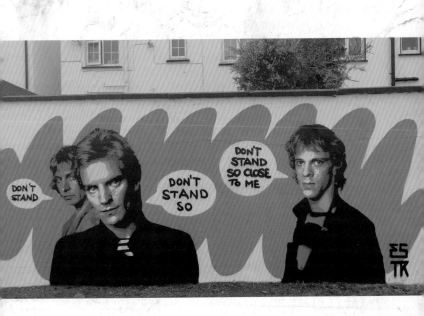

41

SUPER NURSE
Fake

Fake's image of a nurse in her scrubs, wearing a Super Woman mask perfectly captures the determined heroism of those on the frontline.

LOCATION:
Amsterdam, The Netherlands

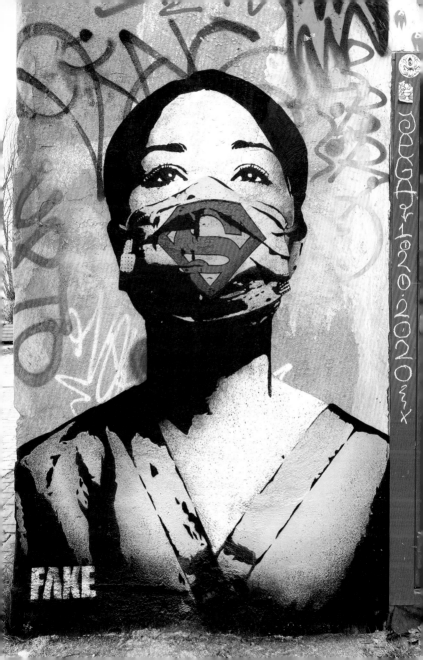

PUR'ELL GOLD
Darion Fleming

As Corona spread around Europe and the US, it was impossible to get hand sanitizer. Here, one market leading brand is portrayed as liquid gold, splashing onto the ground in a corona shape.

LOCATION:
Charlotte, NC, USA

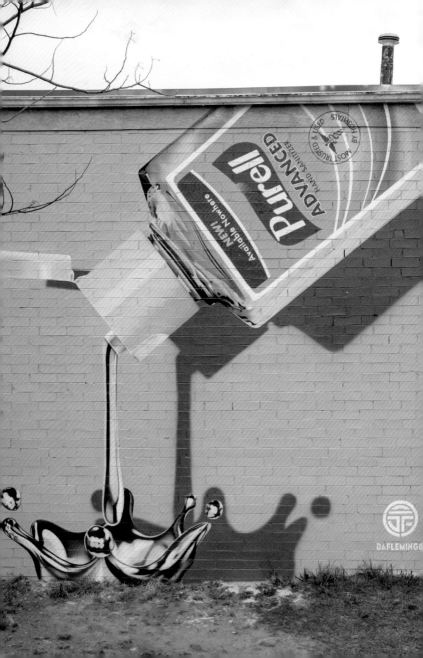

CHEERS
Gnasher

A wonderfully ironic piece, treating the bottle of delicious Corona beer as though it were a vial of the virus. The 'Cheers' typography references the US TV sitcom.

LOCATION:
Royston, Herts, UK

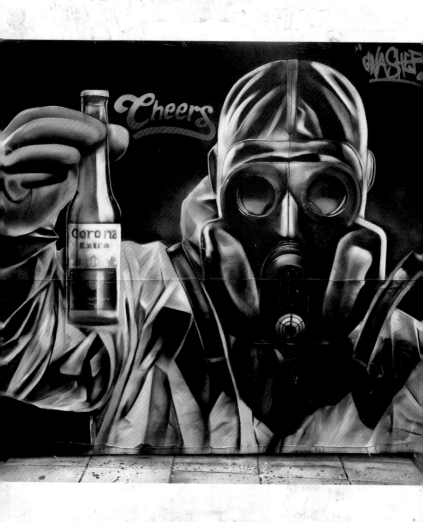

UNITY
Gnasher

The impossibility of proper contact during the pandemic, rather mournfully expressed by these two masked and suited figures.

LOCATION:
Royston, Herts, UK

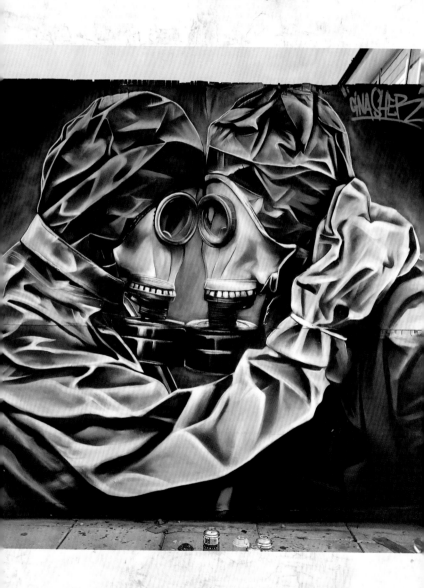

49

PANDEMONIUM
Hijack

The helmets are reminiscent of World War I soldiers, the bag of toilet paper a witty comment on hoarding habits at the start of the lockdowns.

LOCATION:
Hollywood, Los Angeles, USA

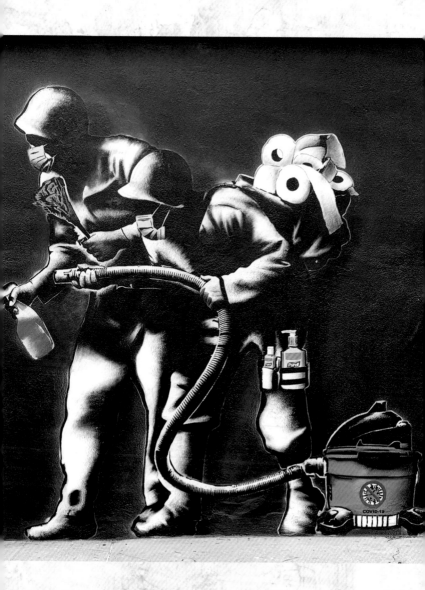

IT'S NOT YOU, IT'S ME
iHeart

A typically witty, ironic image by iHeart, with echoes of Garbo. The child seems thoughtful, unfazed, positive about her enforced isolation.

LOCATION:
Vancouver, Canada

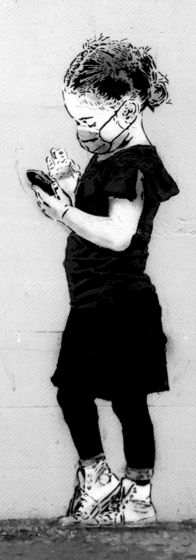

TAKE CARE
iHeart

An ambiguous image, with the figure of the boy literally taking the 'care' sign. A comment on children as asymptomatic spreaders?

LOCATION:
Vancouver, Canada

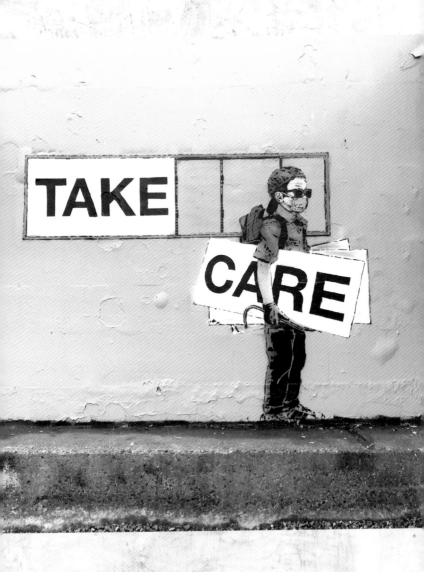

PPE AND CHILL
Jilly Ballistic

Jilly loved images of gas-masked figures long before the pandemic. They have acquired new relevance with her witty use of language.

LOCATION:
New York City, USA

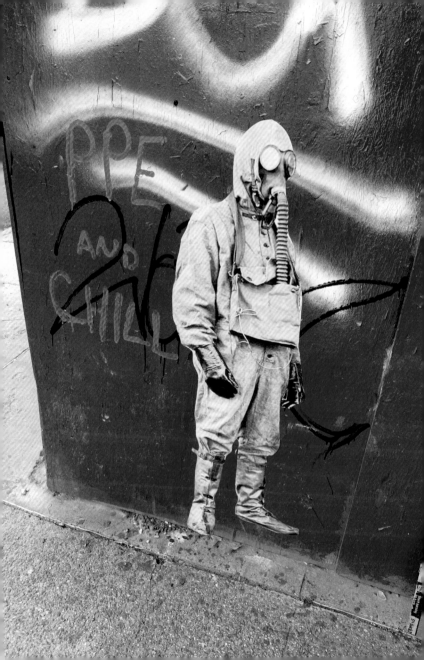

DIVIDED WE STAND
Jilly Ballistic

A clever, thought-provoking twist of language from Jilly, sardonically reversing the words of *The Liberty Song* for Corona times.

LOCATION:

Williamsburg, NYC, USA

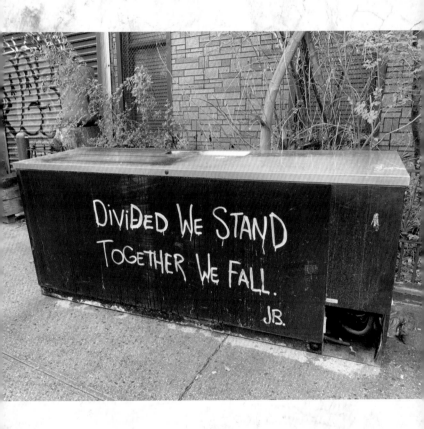

A NEW GENERATION
Jilly Ballistic

Even the youngest childhood can't escape the presence of the virus, in one of Jilly's typically gentle, ironic images.

LOCATION:
Williamsburg, NYC, USA

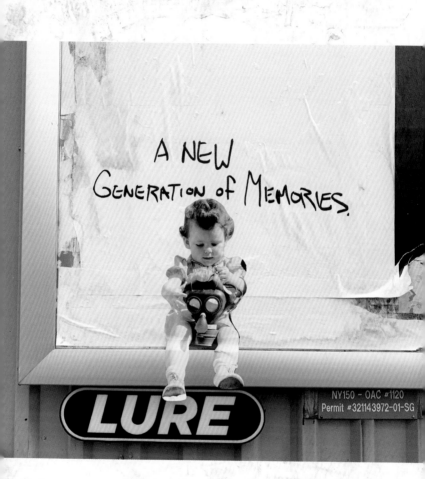

A NEW
GENERATION of MEMORIES.

LURE

NY150 - OAC #1120
Permit #321143972-01-SG

61

THE SHADOW PLAY
Gleb Kashtanov

A great representation of how something so tiny, in unexpected corners, spreads fear. The virus could literally be anywhere.

LOCATION:
Tbilisi, Georgia

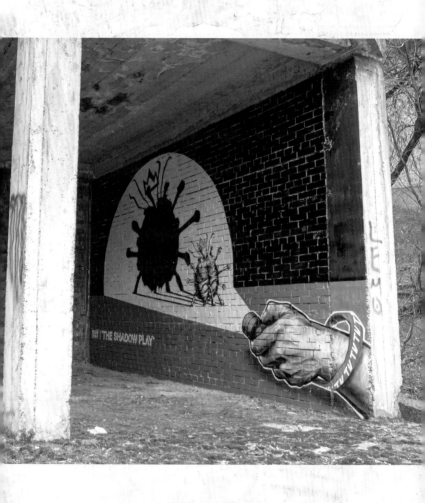

"THE SHADOW PLAY"

INFECTION
Isaac Malakkai

An almost mystical image, capturing the strangeness of the times we're living through, the sickly colours dripping with disease.

LOCATION:
Copenhagen, Denmark

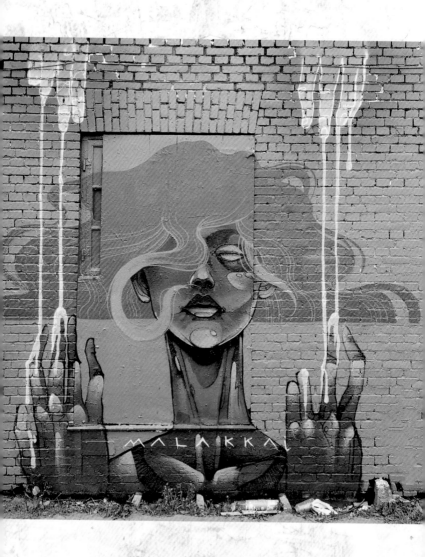

CANCEL PLANS
Corie Mattie

One of four works by Mattie in West Hollywood.
The laptop suggests home working. The dove
of peace, a sign of goodwill and hope.

LOCATION:
West Hollywood, L.A., USA

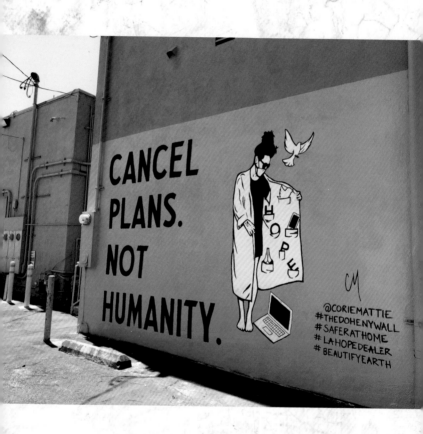

QUARANTINE
Mgr Mors

A perfect image of lockdown: the soaring long-distance migrating stork, sealed in a claustrophobic jar, going nowhere.

LOCATION:
Nowy Sacz, Poland

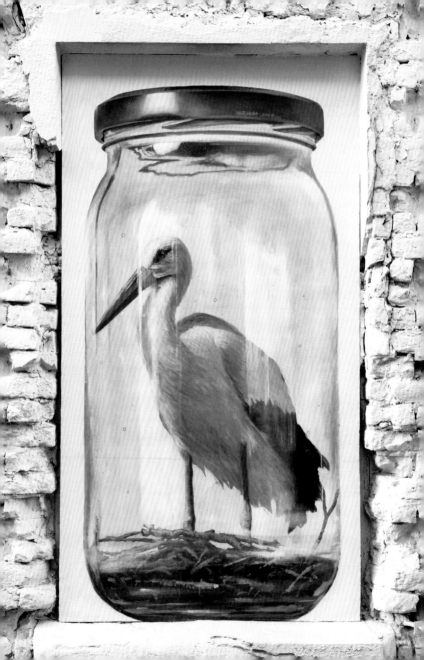

UNTITLED
Damien Mitchell

Damien's figure perfectly captures the oppressiveness of protective suits and masks, clasping his head despairingly in his hands.

LOCATION:
Wagga Wagga, Australia

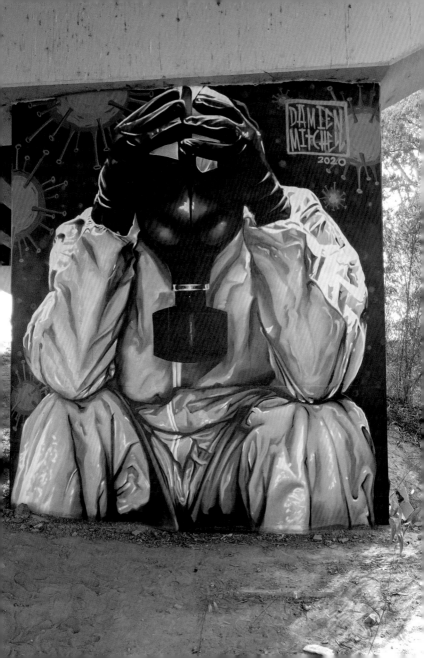

NO PANIC
Henrique 'EDMX' Montanari

Outsize, ironic and funny. When your children and even teddies are in gas masks, it's a very good time to be worried.

LOCATION:
São Paulo, Brazil

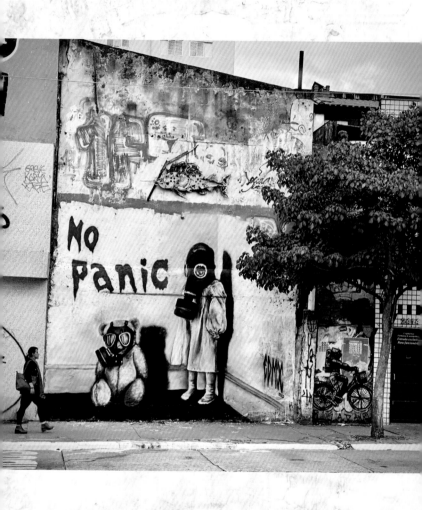

VIRUS DETECTED
Henrique 'EDMX' Montanari

A wonderful portrait of a child, wearing a playful skull mask, is at the heart of EDMX's big, powerful, interactive mural. Download the Artivive app and point your phone's camera at the image, to reveal the work in full, with its hidden message.

LOCATION:
São Paulo, Brazil

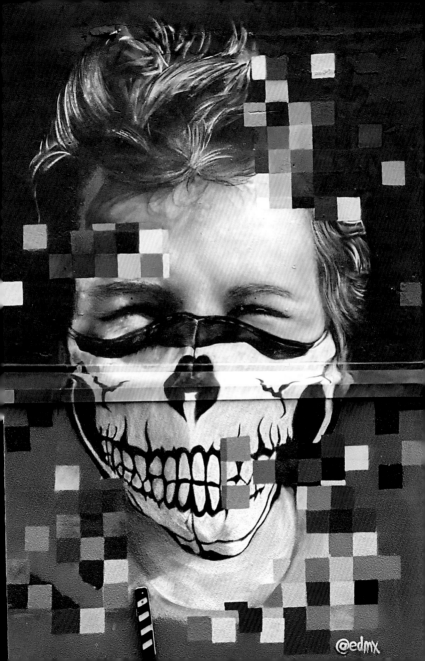

@edmx

CORONA XXL
Mope (Alain Welter)

Mope's sardonic take on the visual language of billboards: Great value coronavirus! Only 1.99 euros! Spread the Fear!

LOCATION:
Hollerich, Luxembourg

CORONAVIRGIN
Munizer

The Virgin, with a world for a halo, weeps behind her mask as she points to the virus inside her. Her fate is sealed: the roses represent the Day of the Dead.

LOCATION:
Madrid, Spain

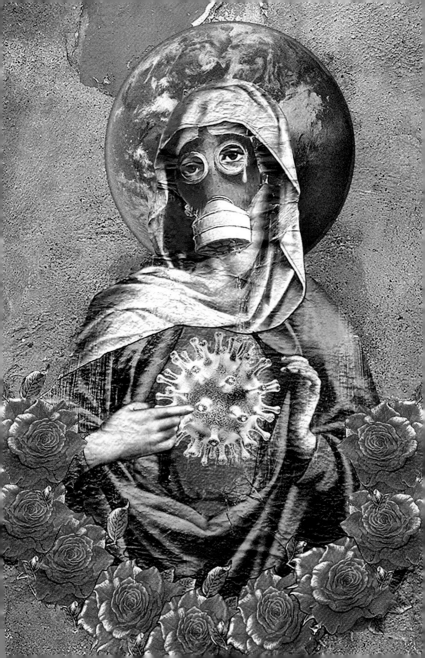

LOVERS
Pøbel

An iconic, wonderfully sexy image by Pøbel, suggesting nothing can resist real attraction: love will conquer all!

LOCATION:
Bryne, Norway

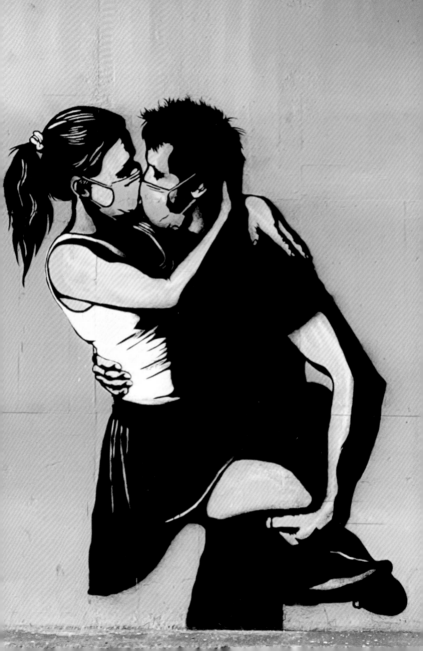

EXTRA CONTAGIOUS
Pyritt

Reminiscent of Coke ads, but also quietly phallic, Corona is not just delicious but very contagious!

LOCATION:
Bergen, Norway

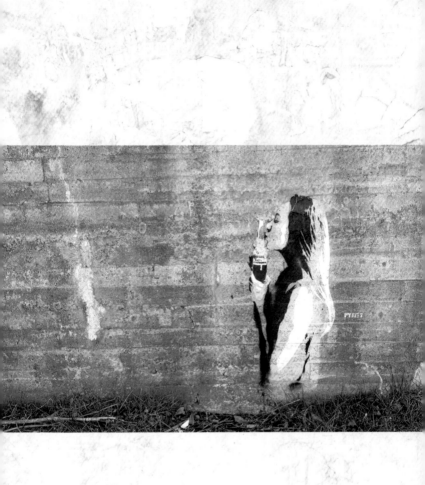

CORONA VENUS
Ragazzini

An imaginary image (Ragazzini created it during Lockdown in his studio) inspired by Botticelli's *Birth of Venus*. Venus rests her hand not on her breasts, but on her lungs. Great lungs are the new measure of beauty.

LOCATION:
Milan, Italy

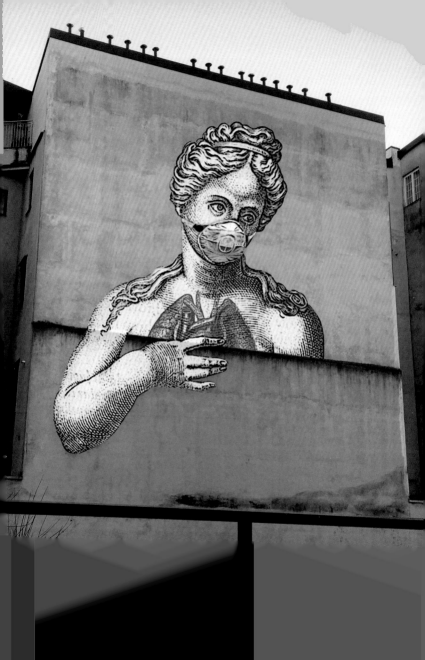

FRIENDSHIP
seiLeise

A wonderfully touching image of young love,
unaffected by the coronavirus. The rose is a
sign of hope for the future.

LOCATION:
Cologne, Germany

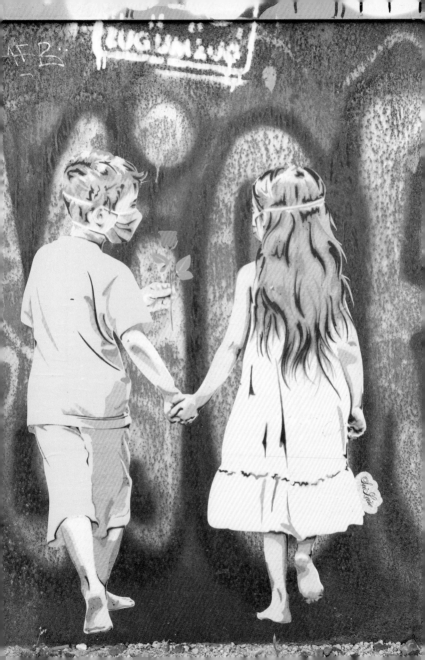

RESPECT
seiLeise

It was the elderly who were most at risk during the pandemic. Here a lovely young girl, in mask and gloves, is looking out for her grandmother.

LOCATION:
Cologne, Germany

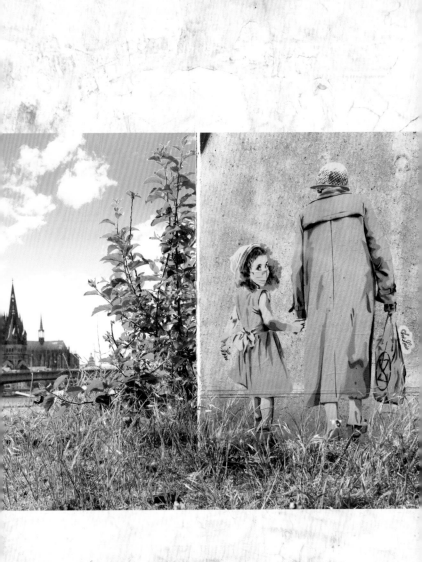

THE KISS
seiLeise

One of the most famous images from World War II, of a sailor kissing a nurse in New York on VJ Day, updated for corona times. There will be victory too over the virus!

LOCATION:
Cologne, Germany

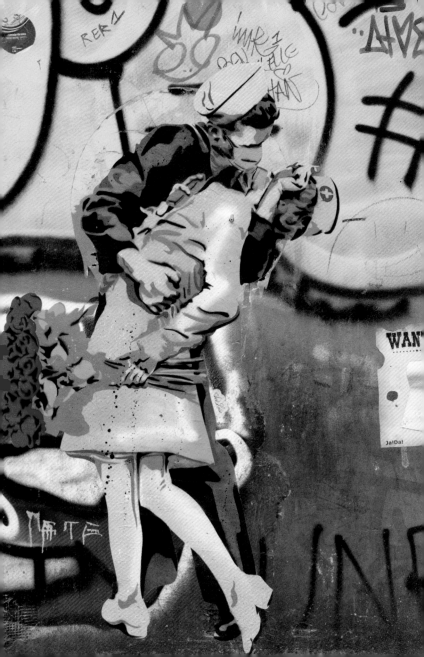

EVERYDAY HEROES
Sid

A mural of thanks for all the frontline medical staff. Sid's subjects look at us with intensity, intelligence and total positivity.

LOCATION:
Canton of Vaud, Switzerland

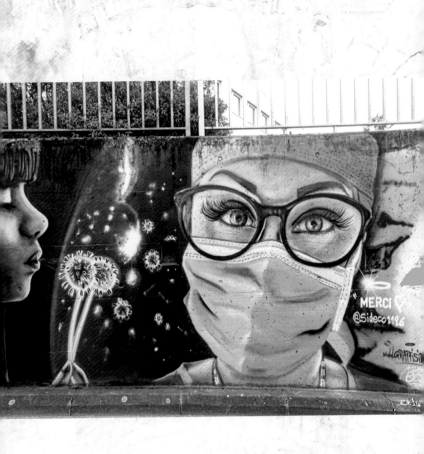

MERCI ♡
@Sideco1196

WWW.GRAFFISi

KELLY VEDOVELLI
Sid

French TV celebrity Kelly, shown wearing a mask. The parrot too is masked, but seems to be warning of a future radiation nuclear leak: Corona isn't the only danger out there.

LOCATION:
Canton of Vaud, Switzerland

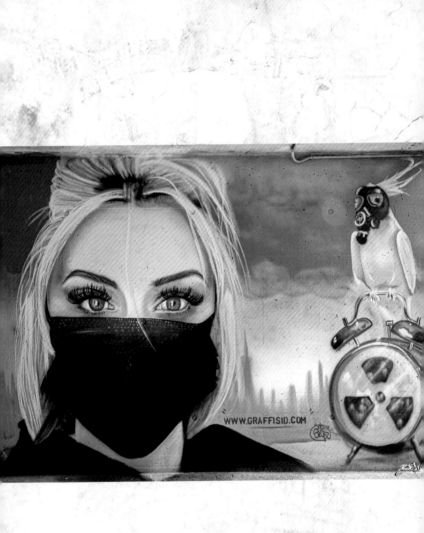

WWW.GRAFFISID.COM

CORONA CARAVAGGIO
Lionel Stanhope

Not even Christ in Caravaggio's *Supper at Emmaus* can quite maintain the spiritual mood when he dons blue plastic gloves.

LOCATION:
Ladywell, London, UK

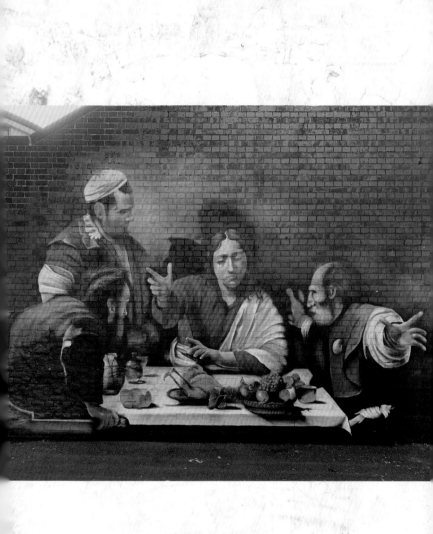

CORONA VAN EYCK
Lionel Stanhope

Jan Van Eyck's wonderful *Portrait of a Man*, still holds our gaze even if his expression is somewhat compromised by the mask. Great head-gear!

LOCATION:
Ladywell, London, UK

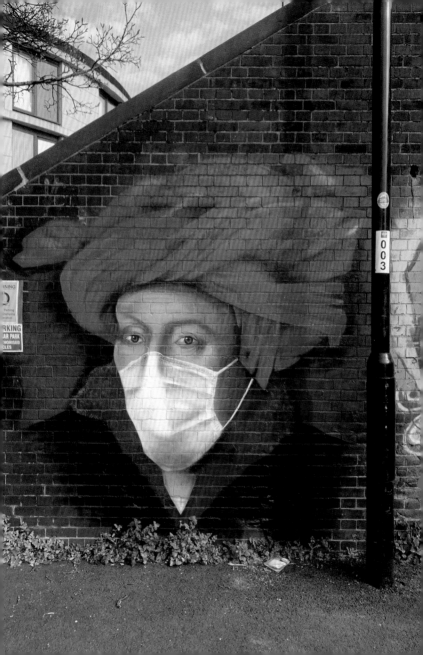

COVID BUSTERS
Stokemaki

Just like in *Ghostbusters*, we need a team who can detect the very scary coronavirus. Spraycan maestro Stokemaki on great form.

LOCATION:
Semarang, Java, Indonesia

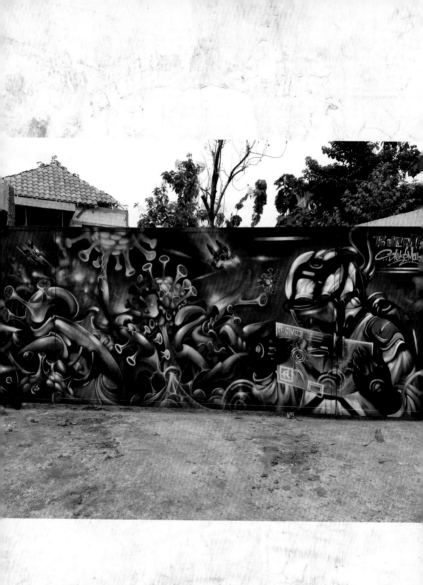

BLACK PLAGUE
Suhaib al Attar

A stunning depiction of a 17th century harbinger of death plague doctor, with steampunk beaked mask and Victorian hat. The setting makes it all the more remarkable.

LOCATION:
Amman, Jordan

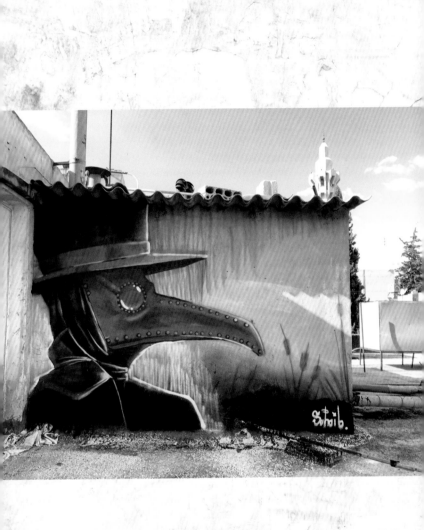

JE SEME A TOUT VENT
Laureth Sulfate

A clever twist on the classic Larousse Dictionaries logo. Laureth's elegant yet sinister figure is sowing coronaviruses rather than seeds of wisdom.

LOCATION:
Lyon, France

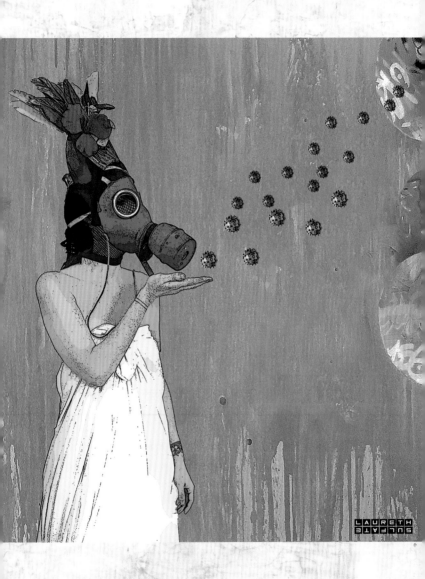

KEEP CALM
Teachr

A typically vapid Prince Harry, latching onto the next bit of attention-seeking virtue signalling. One small benefit of coronavirus is that it wiped the Megan and Harry soap opera off the front page.

LOCATION:
Hollywood, Los Angeles, USA

KEEP

CALM

AND

WASH

HANDS

NETFLIX & HBO
TESLA

For most of us, the real coronavirus experience. How would we survive being idle slobs at home without these two essential drip-feeds?

LOCATION:
Madrid, Spain

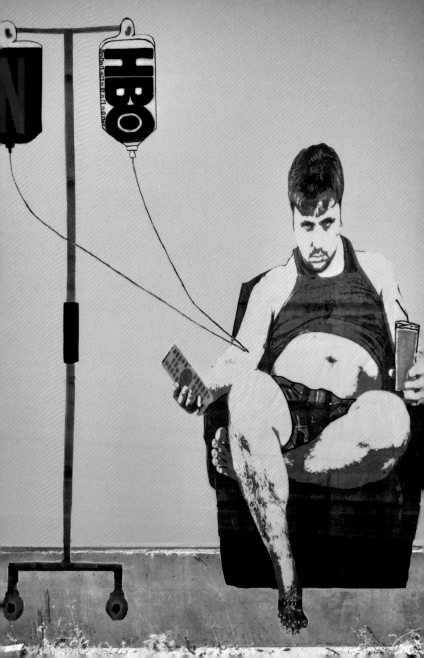

DIVIDED WE STAND
TV Boy

The famous Uncle Sam recruiting poster from 1917, updated for the Corona era. The image brilliantly captures the authoritarianism of Western governments during Lockdown.

LOCATION:
Barcelona, Spain

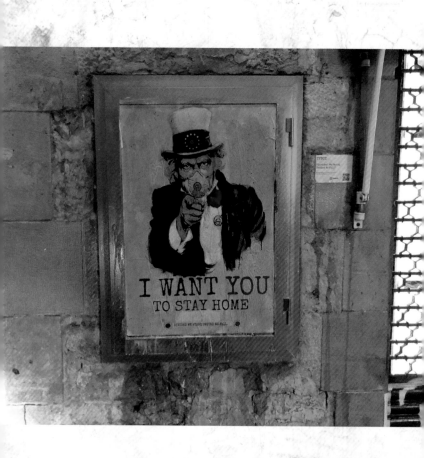

KEEP CALM AND CORONA
Tyler

A sense of Buddhist calm is probably best when dealing with coronavirus. It is all part of life and possibly the result of karma. After death, there is always rebirth.

LOCATION:
Mumbai, India

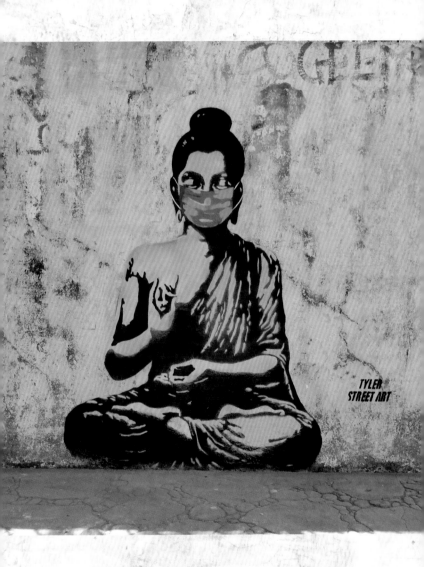

TYLER
STREET ART

LIFE IS BEAUTIFUL
Unknown artist

The message captures brilliantly the mood in Britain as Lockdown was announced. At times the simplest message is the most powerful.

LOCATION:
Shoreditch, London, UK

VIRUS
Severniy Veter

The coronavirus depicted as an escaped mental patient in a straightjacket. The contact-tracing app on the iPhone has spotted him.

LOCATION:
Brest, Belarus

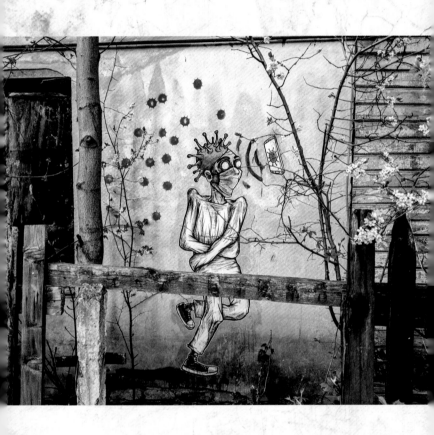

NO GLOVE, NO LOVE
Nils Westergard

A victory salute over the coronavirus, but only if you make sure you wear protection. The alternative is you won't be around for the love.

LOCATION:
Greensboro, NC, USA

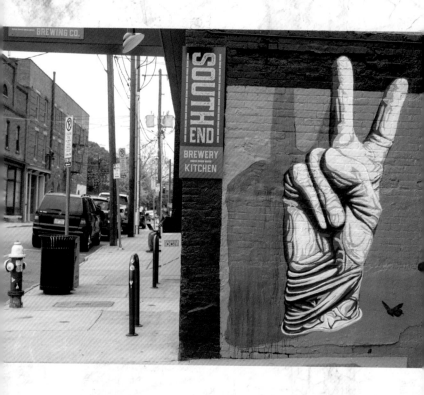

119

ALL THE TACOS
Wrdsmth

Wrdsmth's sentiments always make us smile.
Like us, he's longing for it all to be over.

LOCATION:
Hollywood, Los Angeles, USA

#MelroseStrong

When this
is over,
I'm
eating
tacos.
All the
tacos.

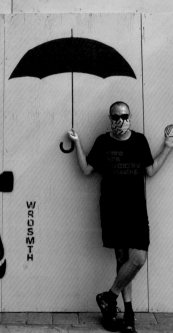

WRDSMTH

@MELROSE
ARTS
DISTRIC

WAIT FOR IT
Wrdsmth

Good stuff is worth waiting for. The coronavirus, Wrdsmth tells us, has really made us think about what and who we care for. Let's hope so.

LOCATION:
Hollywood, Los Angeles, USA

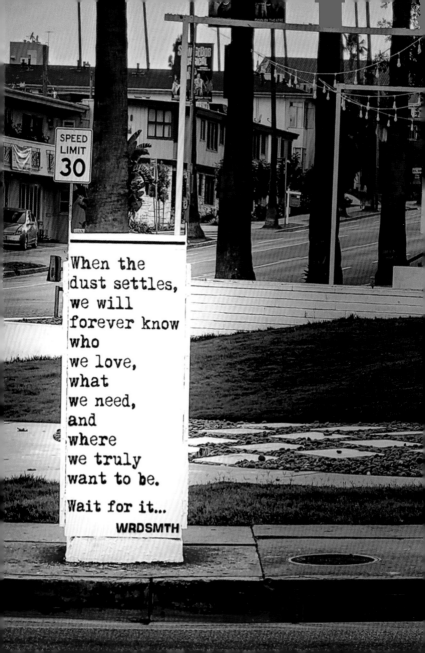

DON'T BE AFRAID
Xamoosh

The figure, in full protective gear, holds up a sign in Farsi, which reads 'don't be afraid'. A somewhat ironic comment, given how he's dressed.

LOCATION:
Tehran, Iran

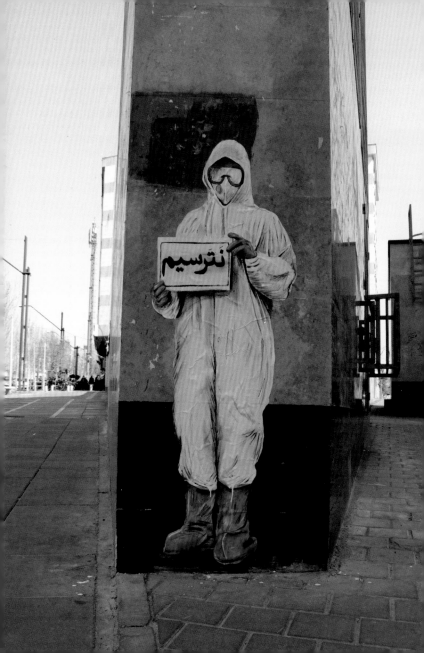

STREET ARTISTS' DETAILS

Graffito would like to thank all the brilliant artists and photographers who have contributed to this publication. We think it will serve as an essential record and memento of a very strange time, where the art really captures the complex emotions, surreal nature and sometimes sardonically funny episodes of The Time of Corona. We would like to extended particular thanks to Pøbel for permission to use his great piece *Lovers* on the cover, and to Tor Stale Moen in Stavanger and Chrixcel in Paris for all their enthusiasm and help.

ARTISTS
In the listings below, we include locations where our street artists are mostly based, not necessarily where they're from.

Anastasiaa and 33° Paris. Photo: Blaise Cendrars
Ben Apache San Francisco. @bennapache
Ardif Paris. (@a–r–d–i–f) ardif@hotmail.com Photo: Chrixcel
ARMX and Sweetsnini Cologne. @adultremix.com
BustArt Basel. artofbust.com
C215 (Christian Guémy) Ivry-sur-Seine. C215.fr
Cel Out Melbourne. celout.org
Eddie Colla Barcelona. eddiecolla.com
Combo Paris. combo-streetart.com Photo: Chrixcel
Deadbeat Hero Vienna. deadbeatheroart.com
John D'oh john-doh.co.uk
ESTR (Emmalene Blake) Dublin. @emmaleneblake
Fake Amsterdam. @iamfake Photo: Mercedes Sibbald

Darion Fleming Charlotte, NC. daflemingoart.com
Gnasher Royston, UK. gnashermurals.com
Hijack Los Angeles. hijackart.com
iHeart Vancouver. iheartstreetart.com
Jilly Ballistic New York. @jillyballistic
Gleb Kashtanov Tbilisi, Georgia. Kashtanovshop.art
Isaac Malakkai Barcelona. Malakkai.es
Corie Mattie Los Angeles. @coriemattie
Mgr Mors Nowy Sacz, Poland. mgrmors.pl
Damien Mitchell Wagga Wagga, Australia. damienmitchell.com
Henrique 'EDMX' Montanari Sao Paulo. edmx.com.br @edmx.art
Mope (Alain Welter) Luxembourg. alainwelter.com Photo: Caroline Martin, Maison Moderne
Munizer Mexico City. ernestomuniz.com
Pøbel Stavanger, Norway. pobel.no Photo: Tor Stale Moen

Pyritt Bergen, Norway. @pyritt_artworks
Ragazzini Milan. @giusepperagazzini
seiLeise Cologne. Seileise.com
Sid Vaud, Switzerland. graffisid.com
Lionel Stanhope London. @lionel_stanhope
Stokemaki Java, Indonesia. @stokemaki
Suhaib al Attar Amman, Jordan. @suhaib_attar
Laureth Sulfate Lyon. laureth-sulfate.com
Teachr Los Angeles. teachr1.com
Tesla Madrid. @teslaproject01
TV Boy Barcelona. tvboy.it
Tyler Mumbai. @tylerstreetart
Severniy Veter Brest, Belarus. @severniy_veter
Nils Westergard Richmond, VA. nilswestergard.com
Wrdsmth Los Angeles. Wrdsmth.com
Xamoosh Tehran. @xamoosh

CREDITS/ACKNOWLEDGEMENTS

The contents, analysis and interpretations within this title express the views and opinions of Graffito Books Ltd only. All images in this book have been produced with the knowledge and prior consent of the artists and photographers concerned.

Art Director:
Karen Wilks
Research Editor:
Lucy Radford-Earle
Editor:
Serena Pethick

FRONT COVER
Lovers, **courtesy of Pøbel**
© Pøbel / BONO 2020
www.pobel.no

Xavier Tapies
An expert on street art, who likes to keep below the radar, Xavier Tapies's books include Where's Banksy?, Street Artists the Complete Guide and Women Street Artists the Complete Guide. Normally resident in a few European cities, he has recently been very locked down in London.

First published in the United States of America, March 2021.
Gingko Press Inc.: 2332 Fourth Street, Suite E, Berkeley, CA 94710, USA
Published under license from Graffito Books Ltd.
© Graffito Books Ltd, 2020. www.graffitobooks.com
ISBN 978-1-58423-761-7 All rights reserved.
Printed in China.